A SACRED SHIFT

A BOOK ABOUT PERSONAL PRACTICE

MARLEE GRACE

For the womxn in my life who held me up in ways I could have never imagined needing, let alone the gift of receiving it without expectation.

Endless gratitude to Spirit, through which this project was channeled.

And to my body, for channeling it.

a sacred shift: a book about personal practice
marlee grace

copyright © 2017 marlee grace
all rights reserved

marleegrace.space
have-company.com
@personalpractice
@softprocess

this book was started in grand rapids, mi
& finished in bolinas, ca

book design + layout • richard wehrenberg, jr.
richardwehrenbergjr.com

artist portait • caitlin metz
caitlinmetzart.com

♥ ♥ ♥

CONTENTS

A
SACRED
SHIFT

INTRODUCTION

Personal Practice began as a project & a place to document my dancing on July 26 2015 in Lancaster, PA while I was attending the Move nt Intensive in Compositional Im ion with my longtime teach itects (Katherine Ferri le, Pamela Vail, & not express y work in thi red by the ra been investing in s.

[handwritten note overlapping text:] Hummus - Olives - Dillz - Cucumbers - Salmon burg - Buttermilk - Broccoli/chard - Arugula - avocado - cauli - PB

This project exists on Instagram. Instagram is an app you look at and scroll through on a smart phone. Sometimes it brings you great joy & sometimes it sucks your soul out of your human body (you have a human body right now) Sometimes Instagram feels like fight club, the first rule of fight club is you don't talk about fight club.

When I first wrote the introduction for this book I kept it vague, didn't even mention that Personal Practice is indeed just a god damn Instagram feed. Alas, that is what it is, and that is also what makes it powerful. That is how celebrities follow it, stay at home moms follow it, my dad checks it on his computer when we are 2,000 miles away from each other, it's how I found people to go on dates with (bless the DM), it's how over 25,000 people tune in to what I do every single day.

When I started dancing daily in August of 2015 I remember checking to see what the hashtag #personalpractice looked like. There were maybe 150 pictures of people doing yoga on the beach so I decided to let the yogis keep it and not try to "connect" but instead just post to my little feed with 300 followers every day. At some point others began to document their own movement every

day using Instagram & use the hashtag - now if you click it you can see over 14,000 videos of people dancing (some of the posts in the tag are still just yogis on the beach, but holy shit that's a lot of content in two years good work humans.)

I am stopped on the street in my small rural town, at coffee shops in Connecticut, at my ex-boyfriend's wedding, in line at the grocery store, walking down the street in Brooklyn. Walking out of the Chicago airport, an entire family on their way to vacation stopped me and thanked me for posting. A video. Of myself moving my body. On a phone app. Every day.

So what is it really? How did this random account I started with ZERO expectation become a sort of strange internet sensation? A source for deep inspiration & connection for thousands of people?

I think it was maybe the FREEDOM of not having an expectation for the end result. Of not hoping for anything outside of myself. I use social media in many different ways, but it was never my goal with Personal Practice to connect with others (I kept true to the Beyonce & Oprah ways and followed zero people) I wanted to post a video every day for accountability, to not forget, to remember to keep practicing.

The good news is it worked - I started dancing more than I had in years - reconnected to my research as an improviser, & found a magic and a healing in my mental health from doing something every day (a huge self esteem booster.)

The weird news is a shit ton of people ALSO loved it, loved it so much they wrote me letters, emails, texts, direct messages, about how it reminded them

they TOO have a body. That they also can do anything they want to. They too can show themselves to the world. It's only scary if we say it's scary.

Putting this book together was also a true act of patience & self forgiveness. Archiving this work in physical form, taking a look at every single video, watching myself in front of the painting in my living room less and less, was incredibly painful. And incredibly healing. And just, it was cool. It was weird. It got really fucking sad. 2016 was so so sad. I cried so so many times. Getting divorced is really sad. Moving away from the only home you've ever known is so fucking sad. BUT! It's also so completely life giving to be free of what isn't serving you anymore. And documenting that year through my movement reminded me that you can feel all of it at the same time.

Personal Practice serves as an archive that chronicles the end of my marriage, moving out of my home, many stages of grief as I witness my friend family have babies, lose those babies, lose their parents, their pets, their friends. It documents me falling in and out of love, more than once. With this everlasting thread of my inability to ever truly fall all the way out. And then closing my business, getting rid of almost everything I own, and moving to California.

It documents my body changing, getting stronger and then weaker, and then stronger again.

There are many outfits, many bad pop songs, all the best oldies, a few haircuts, some good pets, many sacred landscapes.

Personal practice serves as over six hundred love letters. Mostly to myself. But it also allowed for others to tag a friend or a lover. It serves as a 'yes me too'.

Because apparently the feeling of knowing you are not the only one who is FEELING the feeling is indeed the most calming feeling of them all.

It continues to exist, and I am grateful that it catapulted me into regular research, teaching, & collaboration. After posting every day for over a year the feed still exists, however I don't feel the need to show the people every single day. Sometimes I do. Sometimes I don't. I still move my body every day - but my relationship to social media & sharing also changed/is changing.

I love teaching the work of improvisation to others. So many people who take my class found me because of a smart phone app, not because I have a college degree in dance. They come to my class because they too are looking for ways to be in their body, with others, off of the screen. And that has been the greatest gift of all.

I just wanted to get myself to dance more, and the only way I could figure out how was to say 'hey look i did this today' and then do it every single day.

Even when I didn't want to.
Especially when I didn't want to.

PROLOGUE

out of the womb i arrive
twisted
folded in half
legs splayed
tender
eager
upside down
backwards
alert
present

june 2 1988 1:16pm

on the couch in my easter slip
home video tape rolling
janet jackson's rhythm nation blasting
making up a million moves
i'm 4

1992

slowly moving along but not
keeping up with the group

1997

nutcrackers and tutus
and does this body look right
and pointe shoes

1999 - 2006

gets a college degree
in making dance moves

2010

continues to research & explore but
without commitment, without focus
or rigor or paying any attention

2010-2015

something shifts & personal
practice the project is born
in lancaster, pa

july 2015

it seems to be working
so i do it every day

august 2015

everyday dancing as a holy practice

present day

PART ONE:

THE WAYS OF THE WORK

PRACTICES

remembering old beginnings practice

spaces in the togetherness practice

when you feel defeated and don't want
to practice but the practice is what keeps
the defeat at bay practice

looking back to see what's
different practice

always loving everyone i've
ever loved practice

every hour longer awake a more full heart
for being alive less
feeling alone
hello monday practice

permission to feel practice

curing an anxious day with lipstick
& le tigre practice

otis redding practice

every sunday a power day of self
and healing practice

when john and fiona are practicing
on the couch practice

witch practice

saying goodbye to the light sooner
and sooner approaching a solstice
sort of practice

grateful just to be alive practice

low on energy but full of hope
practice

solstice prayer with joni, welcoming
the darkness practice

just sort of throwing my legs up
sort of sunday practice

first day of winter in michigan
and it feels like spring practice

all hail mariah, the true reason
for the season practice

nobody puts baby in the corner
practice

right after i saw lady gaga at the
airport and did not play it cool
and just froze and stared and
felt her power practice

holy practice

everywhere as practice space practice

every noise as sound score practice

how quickly i can remember to be
gentle with myself practice

basking in this winter sunshine on a
tuesday practice

sacred (almost) new moon practice

nice & easy end of day not really
into practicing practice

end of day unstoppable practice

made my dress, made my sweater,
made of magic practice

quiet full moon babysitting as not
to wake the baby practice

feeling alone hello monday practice

preparing to teach practice

slow tuesday still in pajamas letting my
body feel its feelings practice

stand by me soundtrack on the turntable,
coffee in my cup, bagel on my plate, sun
in the sky, hello saturday practice

self as first & foremost practice

alone in bedroom as temple practice

post bath tenderness practice

hiking practice

when there are only twenty minutes
left in the day and you are too tired
to practice but you practice practice

antique store practice

frozen yogurt practice

grateful to be home practice

in the thick of the mess practice

rain practice

today's practice

sound bath practice

first moment awake practice

frankie lymon on the turn table, sorbet
in my bowl, blessed and grateful just
for another day sorta practice

practice as a prayer practice

sunset in the early hours
of the evening practice

in the last minutes of the day saying yes
to this, a daily devotional practice

WORDS OF THE WORK

church of the outside

taking great care in this body and
practicing to the in between

this sweet peninsula is here when
you're ready to return to it's glory

every tiny move a tiny love letter
also the art of just laying down

when the tiniest moves are your
biggest moves and every tiny
dance a love letter to yourself
and an invitation

twenty seven year old grand rapids
woman discovers justin bieber in 2015,
enters into a new joy for living

it's real y'all bieber fever is real and a
spell has been cast and i am a belieber

ocean michigan, beach monday,
life in a snow globe

just another sweet sunday don't
need a hallmark holiday to fall
in love every few minutes

what has this body known
what has this heart held
how have these ribs been touched
how can this body be its own

witnessing to remember

bleeding breathing beaming breaking

another from where u can find me
until october

lake michigan - didn't yet know i
would be leaving

ruin and rebuild me

and everything was new

in silence, in hope, in gratitude, in
mourning, in not surprised, in longing,
in still finding words, in sweet luck
to still inhabit this body and holding
space for those who no longer do on
earth, but in the everything

time of the season for losing it but
staying totally committed to the
GROUNDLESSNESS of being alive

truth in my bones

continuing to choose survival and
showing up for sacred days

standing up, taking care,
sitting back down

finding ways to feel more than
one thing at a time during a
season of nuptials

living everywhere

turning your store into a dance
studio, or how to fall in love
again (with another & yourself)

slowly and patiently learning that
nothing is forever & nothing can
be planned and time time time

a season of not knowing

been crying for forty eight
hours, grieving, celebrating,
been broken for forty eight
hours, driving, writing, been
so deeply awake for forty eight
hours, spinning, alive

sanctuary as home, home as
where this body is

a day of not wanting to share,
of wondering what is sacred

when life is a sacred ceremony
but you still fall hard as hell
keep swimmin y'all

so deeply alone in every way
i've ever longed for

also home, also alma mater,
also fucking frank ocean

surprise duets, lonely church
stairs as almost solitude

hope you find your paradise

believing in divine timing even
when it's uncomfortable, also
good thing tegan and sara made
this album for all of us 12 years
ago because i really need it rn

how to grieve a space, a floor,
how to stay in it when you're
leaving it

PART TWO:

PRACTICAL TOOLS & REFLECTIONS

OUTTAKES

BECAUSE THE FIRST FEW
MINUTES ARE JUST ME
PULLING UP MY PANTS
& CHECKING MYSELF OUT
¯_(ツ)_/¯

usually the song i practice to
everyday is just a song i've been
listening to but let's be real for
the past month i have actually
only listened to justin bieber

grand rapids own al green on the
stereo and no shame for longing for
non aloneness practice

and special thank u to my dad who
suggested this song & by making me
is responsible for my music taste and
song choices u may thank him and my
mom for taking me to dance class and
never missing a show

every time i think i finally learned a
thing is the exact time i should write
down 'this will not be the last time
you learn this thing, and that is ok'

kitchen duets as everyday gratitude

really into shawn mendes really into
teen boys talking about their feelings

the ensemble makes room for a soloist
she waits, her partner arrives
they duet in unison
they rejoin the ensemble together
(jim o'rourke as car music, california
cows as spirit ensemble members)

in the choir room of the church where
my parents got married, where i snuck
off to make out, where i graduated
high school, where i found some sort
of spirit outside of myself, where xmas
eve is candlelit at midnight, where i
returned on this week's new moon

every first draft is perfect, because
all a first draft has to do is exist

– jane smiley

daily ritual and routine have
become incredibly important
to me, especially as an addict/
human being prone to impulsive
behavior, i am incredibly good
at making excuses for not taking
care of myself or doing what is
good for me, so this is a powerful
way to not negotiate

as soon as i show up to it something
shifts, and i am reminded that if i do
not show up i give myself no chance
to see what's there

tough to find a steady rhythm in my
days, in my work, in this practice,
with this body ... showing up
anyways and finding the capacity
for more every time

a body, a ladder, a plant, a record
crackle, a moment, a chair, a
cabinet, a woman, a hope, a paint
test, a memory, an enormous grief,
a river of every blessing

two thousand sixteen has been a complete
shit show but i did learn hanging out with
myself is fucking awesome

staying committed to moving the table to
move the body because the hardest part
of the moving is not the body or the table
it's the deciding, so when you remove the
deciding and do the doing it's not so hard

self care survival tips :
cut hair off, listen to usher

when you feel the urge
to chop all your hair off
listen to abba instead

i have never felt so unapologetically my
wild impulsive whiny fancy fabulous
empowered beautiful unstoppable self

when you are grieving and beaming at
the same time and learning to balance
and letting yourself cry and also be
filled with endless joy and maybe there
are no ends or beginnings and you
bought yourself a new bathing suit for
your beach life and falling in and out
is just a part of waking up

kitchen as magic, magic as kitchen,
home as body, home as where body is

sunrise, moon in sky

when the practice is personal and the
personal is togetherness

been forgetting my morning pages,
not drinking enough water, buried
in emails, life transitions abound,
and dreading this daily commitment
but holy holy it continues to be my
greatest teacher

over committed, totally distracted,
moderately centered

every full moon coming for you feel
you could ever feel in one body

summer 2016 or how to live for
yourself without outside validation

REFLECTIONS ABOUT
MY SHIRTS, BY OTHERS

Who makes the boob shirt

Boob shirt

there are shirts too!

Le Tigre is definitely the soundtrack
to the boob shirt.

we need her shirt

I just noticed her shirt

That shirt though...

her shirt

Super cute shirt! Where did you find it?

don't you love her shirt lol

Look at her awesome t!

Amazing shirt btw!

the shirt!

Also, can I have her shirt?!

Get me one, too!

let's get matching boob shirts too

I need that top

need the top

That shirt!

I love your shirt!!

I love this one . And her shirt

That sweatshirt

Yaaaaaaaaas love the moves
love the sweatshirt love the vibes

This is a special one! And that
sweatshirt though.

where is your sweater from?

Where did you get your shirt?
also, I love your shirt tonight!
Where is it from?

Love your shirt.

Your shit

I have that shirt!

I feel like you would appreciate
this sentiment, and her t shirt
collection

Where can I find that sweatshirt?

where is your sweatshirt from??

I just love that sweater

Yes this outfit is my shit

Your new sweater! Looks FANTASTIC!
Magic magic magic.

Great dress! Love the pockets.

Sweater looks so goood

Love the dress

Like your dress

MORE THINGS OTHER PEOPLE SAID TO ME ABOUT A VARIETY OF THINGS

I feel like I've stumbled across
an inside joke that I totally
don't get

Nails nails nails. Yes queen!

This dress fits you perfectly!

What does your sticky note say?

never forget that you are of the
earth and you are always good
enough

Can't like this enough. You've
got so much back up. You've
got this.

Love your jeans !! What brand ??

Also loving the jeans!

Nice tight jeans. Just saying.

Skin tight and stretchy...perfect pants.

But THESE jeans

You look super good in them jeans

I'm not sad anymore

My 4 1/2 year old son and I dance to
Wuthering Heights so often, that he
named his stuffed pig "Cathy"! He
wanted me to tell you that your
dance is "fantastic!".

Hair is majestic

Love the haircut

this new hair do seems to have
given you a new life. Looks great -
seems like it makes you feel great

You are rocking that short bob,
I commend you

That haircut is fantastic!

omg lmfaooo I love this

Praying attention

Diving back into the Mother

My 4yo daughter & I watch your practice daily. After viewing this morning's video, she quietly asked, "Is she dancing on a whale?"

Guys, what is she practicing? Is it dance? Is it yoga? Even the dog is in the know. #NewFollower

"She dances very much better than you, mom" my 4 year old every night watching you.

Where can I find those shorts??

Need those shorts

Hi, I came across your account
and I was just wondering what
you practice for?

I love that you are smiling.

Yes !!! finally smiling !!! You look
so amazing when you smile ;)

that smile tho

Great smile!!!

Amazing smile

My favorite so far. Beautiful smile
Gemini!

Love your beautiful smile 🤍

Lmfao

For real though, this woman can't dance. The best I can figure, people are liking this because of her free-spirited self-abandon.

What is she even doing?

Do you live in paradise?!

Reminds me of how Kermit the frog gesticulated when he's excited.

Why is your head always flopped forwards?

Wtf did i just watch?

What the hell lol

literally wtf

Thank you for the reminder
that we don't need anything
special to choose positivity
and self love.

why is she famous this looks
like a cat having an exorcism

Silence is always a trusted
friend.

omg I'm dying, this girl thinks
she can dance

Wus wrong wid dis bitch haha

Total peacock

YOU'RE A TRUE AMERICAN DOLL

Can u respond to my dm please

You're a plant!!!

Love the dance I'm a fan go pro

I love you and you're saving
my life right now.

Awww, i hope none of your loved
ones died, cause THAT you can
do nothing about.

Those jeans are giving me life

where are your pants from?
They're really cute!

I luv ur hair

I love your vids so much but you
should eat pasta instead

fruit salad + destiny + chair +
galloping + scrape + morning +
david + farm + heaven + sandwich
– Andrew's list from the first day we
made something together

What's with today, today?
– Empire Records

loneliness sometimes makes the
nicest things
– Erin Guido

THOUGHTS ON THE OWL LAMP

Bout to throw that lamp off the shelf
just the way I like it beauty

The owl is jammin with you and the
honey cone.

Owl lamp

I just keep looking at the lamp

how does it not fall

My teeth hurt from watching the
owl lamp bounce around ha.

Watch that lamp.

Love watching your videos.
Also love your owl lamp!

Your owl lamp shaking ever more
close to the edge gives me anxiety

Yassss 😂😂 that lamp almost came
down... She lit

Watch out mr.owl!!!!

Girl.....werk.....but that lamp

That lamp

UNPUBLISHED
REFLECTIONS

I planned my moving day around
tickets i bought to a concert of a
band i really like that a boy i have
sex with sometimes told me about

That boy is not my boyfriend

Sometimes he buys me dinner

And is excellent at touching my body

But i am not his girlfriend

I am a girl

And i am his friend

because in this shifting is blessing
and in this blessing is aloneness
and in this aloneness i have shifted

The moon was big

My dad said "i bet that looks
incredible through a telescope"

I've never heard my dad talk about
the moon

Until this morning at 6:17am

He couldn't remember if he'd ever
been to an ex girlfriend's wedding

He felt he must have

I felt alone and worried

I felt unmarried

I am unmarried

I don't ever want my dad to die
I don't ever want a scorpio to die

Walk in
Talk
Be cordial
Don't make too much eye contact
It's cool
Leave
Public sobbing

Text kate and tell her you love her

I always have to pee
So sometimes i 'try' to pee a lot
So that i wont have to pee later
Always sort of feels like a hassle
Or a waste of time or something

Moon is low

Moon is mine

Moon does not belong to me

Moon days are yours

Now this moon that was ours is everyone's

It was good we held it

It was good

It never felt as bad as you said it did

But when i learned to cook rice at 28 years old i understood, even for a moment, why it was no longer ours

I cannot believe i almost moved into that house
I cannot believe my period was 10 days late

PART THREE:

A CATALOGUE OF THE FACTS

SONGS

i know, that i feel more than you do

La Loose : Waxahatchee

Invisible Touch : Paul Collins

When You Find Out : The Nerves

Comin Home : Leon Bridges

Ride a White Swan : T-Rex

A Gossimer song, played
backwards on my tape player

Death with Diginity : Sufjan Stevens

Gimme Little Sign : Brenton Wood

alive, alive

All I Want : Joni Mitchell

Rocket Man : Elton John

The Girl From Impanema : Stan Getz & Jao

Back Pocket : Vulfpeck

Down Again : Radiator Hospital

Met Him on a Sunday : Laura Nyro

Nobody But Me : The Human Beinz

This Old Heart of Mine : The Isley Brothers

Two Princes : Spin Doctors

take a listen to your spirit
it's cryin out loud

I Don't Want to Know : Fleetwood Mac

now you tell me that i'm crazy
it's nothing that i didn't know

Lover Man : Billie Holiday

Heart of The Country : Paul & Linda McCartney

Do you Believe in Magic : The Lovin Spoonful

Swan Lake Soundtrack

The Swimming Song : Loudon Wainwright III

Where You Lead : Carole King

Summer Samba : Walter Wanderley

The Wind : Cat Stevens

Eye To Eye : Astronauts, etc

Want Ad : The Honey Cone

Here Comes My Baby : The Tremeloes

Spirit in The Sky : Norman Greenbaum

S & M : Rihanna

Right Back Where We Started :
Maxine Nightingale

Marvin Gaye : Charlie Puth & Meghan Trainor

Hey Mama : David Guetta w/ Nicki Minaj

I Will Dare : The Replacements

Chris Apple making music under a tree

Steve Reich (on the record player)

Hotline Bling : Drake

No Matter What You Do : Badfinger

Iko Iko : Dixie Cups

Breakaway : Irma Thomas

Lips Are Movin : Meghan Trainor

walk with me
walk with me

Try Me : James Brown

Good For You : Selena Gomez

Partition : Beyonce

He's So Fine : The Chiffons

Holiday : Madonna

Heaven Is A Place On Earth : Belinda Carlisle

Come See About Me : The Supremes

11th Dimension : Julian Casablancas

Give Him A Great Big Kiss : The Shangri Las

22 : Taylor Swift

Baby Bye Bye : Kitty, Daisy, & Lewis

Cry Me A River : Justin Timberlake

Lights Out : Angel Olsen

i wish i had an idea of what i need

Wish I Knew : Sharon Van Etten

Mr. Postman : The Marvelettes

Lollipop : The Chordettes

Why Do Fools Fall In Love : Frankie Lymon

Decapaton : Le Tigre

Under Cover of Darkness : The Strokes

Are You That Somebody? :
Aaliyah feat Timbaland

Girls Can Tell : The Crystals

Turkey Trot : Little Eva

you're walking meadows in my mind
making waves across my time

Strange Magic : ELO

I've Been Loving You Too Long :
Otis Redding

Photograph : Weezer

Supermoon : Allison Crutchfield

Newage Girl : Deadeye Dick

Mr. Lee : The Bobbettes

Keep Me In Mind : Tashaki Miyaki

Hear : Moonpools & Caterpillars

You Really Got A Hold On Me :
Smokey Robinson

Do You Love Me Like You Used To? :
Best Coast

Good Morning Blues : Assateague

Hot Love : T. Rex

It's So Easy : Ted Lucas

Fantasy : Mariah Carey

Stupid Cupid : Connie Francis

More Of This : Vetiver

Come And Get Your Love : Redbone

Sorry : Justin Bieber

Love Yourself : Justin Bieber

Never Let You Go : Third Eye Blind

Judy & The Dream Of Horses :
Belle & Sebastian

So Far Away : Carole King

Pumped Up Kicks : Foster The People

Spin The Bottle : Juliana Hatfield Three

A Case Of You : Joni Mitchell

Got To Give It Up : Marvin Gaye

No Scrubs : TLC

All I Want For Christmas Is You :
Mariah Carey

Christmas in LA : Vulfpeck

Sittin On The Dock Of The Bay :
Otis Redding

Start Me Up : The Rolling Stones

River : Leon Bridges

Sunday Candy :
Donnie Trumpet &
The Social Experiment

it's not fair to let me fall
and not be there for me at all
and if you wanted me to dance
why didn't you say so?

Absent Year : Radiator Hospital

Do You Love Me? : The Contours

Train Song : Vashti Bunyan

Jimmy Mack : Martha & The Vandellas

Vigilante : Judee Sill

Jump In The Line : Harry Belafonte

What Do You Mean? : Justin Bieber

Your Love Keeps Lifting Me Higher :
Jackie Wilson

Changes : David Bowie

Tired Of Being Alone : Al Green

Hello : Adele

Manha De Carnaval : Stan Getz

Cry To Me : Solomon Burke

You Got What I Need : Freddie Scott

Jealous : Beyonce

Something's Got A Hold On Me :
Etta James

You could have done anything,
if you wanted
And all your friends and family
think that you're lucky
But the side of you
they'll never see
Is when you're left alone
with your memories
That hold your life together,
like glue

This Is The Day : The The

Every Little Thing She Does Is Magic :
The Police

Got My Mind Set On You : George Harrison

White Collar Boy : Belle & Sebastian

Shout : The Isley Brothers

Runaround Sue : Dion

This Kiss : Faith Hill

Soul Man : Sam and Dave

I'm Gonna Be (500 Miles) : The Proclaimers

Mama Said : The Shirelles

Halo : Beyonce

Dreams : The Cranberries

SO ALL ALONE
I KEEP THE WOLVES AT BAY

Train In Vain : The Clash

Tilted : Christine and The Queens

Since You Left : Big Eyes

Yakety Yak : The Coasters

Oh Yoko : John Lennon

Meet Virginia : Train

Get into The Groove : Madonna

Shining Star : Earth, Wind, & Fire

Flawless : Beyonce & Nikki Minaj

Love Is All Around : The Troggs

Sunday Girl : Blondie

Planet Queen : T Rex

In The Summertime : Mungo Jerry

Heartbreaker : Pat Benatar

Company : Purple 7

Be My Baby : The Ronettes

Stuck In The Middle With You :
Stealers Wheel

Baby I'm An Anarchist :
Sung IRL by Laura Jane Grace

Just to remind you I'm a mistake
How come you don't want to know?

One Day : Sharon Van Etten

I Am The Hotstepper : Ini Kamoze

Roar : Katy Perry

Come On Eileen : Dexy's Midnight Runner

Rich Girl : Hall & Oates

Work : Rihanna

Ain't Too Proud To Beg : The Temptations

I'm so scared of you all the time
I get scared when you cross my mind
Get so scared I think I might die
I'm sure I would prefer
If you weren't quite who you were
If the lines that we drew could blur
If I could only find the words

Stay Single : Mighty Clouds

i had some dreams
they were clouds in my coffee
clouds in my coffee

You're So Vain : Carly Simon

The Air That I Breathe : The Hollies

Better Son/Daughter : Rilo Kiley

Dancing In The Moonlight : King Harvest

You & Me : Penny & The Quarters

Total Eclipse Of The Heart : Bonnie Tyler

S.O.S : Abba

Sunday Morning : No Doubt

It Could Have Been A Brilliant Career :
Belle & Sebastian

this world is bullshit

Criminal : Fiona Apple

I live my life to the limit and I love it
Now I can breathe again,
baby, now I can breathe again

Real : Jennifer Lopez & Ja Rule

Mambo Number 5 : Lou Bega

Two Become One : Spice Girls

Hello, Goodbye : The Beatles

The Love You Save : The Jackson 5

Earned It : The Weeknd

i don't want to check out
but i've run out of space

I Don't Know How To Deal With It :
Stephen Steinbrink

Rescue Me : Fontella Bass

Temperature : Sean Paul

Picture Book : The Kinks

Call Me Maybe : Carly Rae Jepsen

Coconut : Harry Nilsson

Lost Dreamers : Mutual Benefit

i'm a goddess on my knees

Bitch : Meredith Brooks

Any Man of Mine : Shania Twain

Instrumental : Tumbalo

Coffee & TV : Blur

You Oughta Know : Alanis Morissette

Romeo & Juliet : Dire Straits

Consideration : Rihanna

Magic Man : Heart

Peg : Steely Dan

Walk On By : Dionne Warwick

thunder only happens when it's raining

Dreams : Fleetwood Mac

Love On The Brain : Rihanna

You Got It : Roy Orbison

Sex Machine : James Brown

Mesmerize : Ja Rule feat
Ashanti

I'm A Flirt : R Kelly

Easier Said Than Done : The
Essex

*with my poor heart in my throat i begin
living a dream come true*

Waterfall : Judee Sill

Girl On The Wing : The Shins

Famous : Kanye West

Everything Put Together Falls Apart :
Paul Simon

I Love You Always Forever : Donna Lewis

Tusk : Fleetwood Mac

Touch My Body : Mariah Carey

One : Harry Nilsson

Hey Ya : Outkast

Country Grammar : Nelly

Edge Of Seventeen : Stevie Nicks

Dream Lover : Bobby Darin

Oops I Did It Again : Britney Spears

Campus : Vampire Weekend

Out Of My Head : Fastball

The Middle : Jimmy Eat World

Roll To Me : Del Amitri

Grey Hair : Waxahatchee

Me Too : Meghan Trainor

Send My Love To Your New Lover : Adele

Let's Groove : Earth, Wind, & Fire

Anthem Of A Seventeen Year Old Girl :
Broken Social Scene

Too Late : Carole King

Shake It Off : Taylor Swift

Will You Love Me Tomorrow : The Shirelles

Sugar, Sugar : The Archies

All I Have To Do Is Dream :
The Everly Brothers

Baby, Now That I've Found You :
The Foundations

I got nothing to give you, you see
Except everything, everything,
everything, everything
All the good and the bad

I Never : Rilo Kiley

The Sign : Ace Of Base

Tell Me Something Good : Chaka Khan

Pursuit Of Happiness : Kid Cudi

You Make Me Wanna : Usher

Lose Sight Of You : Radiator Hospital

Just One Of The Guys : Jenny Lewis

Another Night : Real McCoy

Unchained Melody : The Righteous Brothers

Wuthering Heights : Kate Bush

Sorry : Beyonce

Can't Get Enough : Rooney

Too Good : Drake & Rihanna

Door : Nice As Fuck

Ought (live)

No Woman : Whitney

All For You : Janet Jackson

Just What I Needed : The Cars

Always On Time : Ja Rule feat Ashanti

What A Girl Wants : Christina Aguilera

Golden Days : Whitney

Love Is Strange : Mickey And Sylvia

Amiina

London Bridge : Fergie

Paper Bag : Fiona Apple

Come Go With Me : The Beach Boys

Four Five Seconds :
Rihanna, Kanye, Paul McCartney

Habit Of You : Arthur Russell

Stand By Me : Otis Redding

Cold Water : Justin Bieber

Something In The Way You Move :
Ellie Goulding

Anything Could Happen : Ellie Goulding

every time i listen to ellie goulding
i feel really good

every time I listen to ellie goulding
i feel happy

every time i listen to ellie goulding
i feel good about my body

every time i listen to ellie goulding
i don't feel worried

every time i listen to ellie goulding
i am glad i am single

every time i listen to ellie goulding
i sing along

every time i listen to ellie goulding
i think 'yes having a crush is cool'

every time i listen to ellie goulding
i do that thing with my shoulders

every time i listen to ellie goulding
i am grateful

every time i listen to ellie goulding
i am less alone

Dancing In The Dark : Bruce Springsteen

How Will I Know : Whitney Houston

Wake Me Up Before You Go-Go : Wham!

Ivy : Frank Ocean

Blessings : Chance The Rapper

Because The Night : Patti Smith

Born Again : The Afterglows

Once In A Lifetime : Talking Heads

My whole life
Was like a picture
Of a sunny day

Modern Girl : Sleater-Kinney

No Problem : Chance The Rapper

Goodbye Stranger : Supertramp

Easy Lover : Phil Collins

Get Me Bodied : Beyonce

Lovely Day : Bill Withers

Whose Bed Have Your Boots Been Under :
Shania Twain

Oh La La : Faces

Hey! Baby : Bruce Channel

Complicated : Avril Lavigne

Ruler Of My Heart : Irma Thomas

California : Joni Mitchell

Solo : Frank Ocean

Never Be Like You : Flume feat Kai

E.I. : Nelly

Strange : Patsy Cline

For Free : Drake

Goodbye Earl : Dixie Chicks

Blinded By The Light :
Manfred Mann's Earth Band

Something To Talk About : Bonnie Raitt

castin your spell on me

Oogum Boogum Song : Brenton Wood

This Is What You Came For :
Calvin Harris With Ri Ri

Mirror : Justin Timberlake

Father Stretch My Hands Pt. 1 : Kanye West

Ain't No Mountain High Enough :
Marvin Gaye & Tammy Tyrelle

Speak Slow : Tegan & Sara

Take It On The Run : Reo Speedwagon

Let Me Love You : Justin Bieber

Eat At Home : Paul & Linda McCartney

212 : Azalea Banks

Shut Up And Dance : Walk The Moon

Jolene : Dolly Parton

My Sweet Lord : George Harrison

Gold : Kiiara

California : Phantom Planet

Gonna Get Along Without Ya Now :
Skeeter Davis

I might not stay but at least
I would've been around
Cause there's something about
what happens when we talk

Something About What Happens :
Lucinda Williams
(sung by Sam Cook-Parrott
& Allison Crutchfield)

My Heart Does Swell : The Sandwitches

Let Me Roll It : Wings

Suzanne : Leonard Cohen

Starving : Hailee Steinfeld

Godspeed : Frank Ocean

Wut's Luv : Fat Joe feat Ashanti

Gone : Afrojack

Say It : Flume feat Tove Lo

Hurts So Good : Susan Cadogan

Intern : Angel Olsen

Arrow Through Me : Wings

That's All : Genesis

Smooth : Santana feat Rob Thomas

Like A Prayer : Madonna

I Can't Stand The Rain : Ann Peebles

Love More : Sharon Van Etten

Pistol Packin Mama : Al Dexter

Freak : Lana Del Ray

Let My Love Open The Door :
Pete Townshend

Crazy Love : Van Morrison

Stitches : Shawn Mendes

Thinkin Bout You : Frank Ocean

Jaan Pehechaan Ho : Mohammed Rafi

Me Myself & I : Beyonce

If She Wants Me : Belle & Sebastian

Doctor My Eyes : Jackson Browne

Natural Woman : Aretha Franklin

Red Eyes : War on Drugs

You've Got A Friend : Carole King

I'm Closing The Door : The Afterglows

Why I Came To California : Leon Ware

PEOPLE WHO APPEAR

Baby Penelope
John Hanson
Jacqueline Suskin
Sarah Gottessdiener
Will Owen
Heather Baker Jackson
Ben Baker Jackson
Chad Houseman
Alex Difigilia
Alyssa Natoci
Ariel Frey
Cedar Baker Jackson
Laura Jane Grace
Atom Willard
Rosemary Liss
Molly Ross
Hayley Hungerford
Tristan Koepke
Azalea Vitaz

Liz Migliorelli
Sara Strickler
Rebecca Bruno
Katie and Allison Crutchfield
Joey Brubeck
Casey Ryder
Cedar & another child
Kyle Hunter
Baby Louie, baby of Mark & Carrie
Carly Bond
Andrew Maguire
Caitlin Enwright
Anna Vogelzang
Jack Sjogren

ANIMALS

Yoko Ono the cat
Christine's cat
Carly the dog
Ginger the dog
Bowzer the dog
Auzzie the dog

PLACES

Graveyard (Lancaster, PA)

Have Company (Grand Rapids, MI)

John's Room

The Dining Room

Sam's yard (Cedar, MI)

Sam's living room

A field of goldenrod by Sam's house

Nina Creek (Portage, WI)

My Grandfather's yard

Rosa Parks Circle

Lake Michigan

The dining room, from the
perspective of the record player

South Bend Museum

The doorway to the kitchen

The floor of the dining room

Sam's yard again, the
other side of the house

A rest stop, middle America

The dining room, from the perspective
of the dining room table

Ariel's driveway

Ariel's car

The Sparrows Coffee Tea
& Newstand (Grand Rapids, MI)

Sam & Lisa's wedding (San Diego, CA)

Rachel's living room

LAX

Christine's bedroom (Detroit, MI)

The kitchen at Benjamin

Lake Michigan, Saugatuck Dunes

The outlet mall with Jeff

Bellaire, MI

Outlet Mall Bathroom

UICA lobby

Christine's Living Room

Sidewalk (Detroit, MI)

The kitchen at Benjamin
from the other side

Kitchen doorway

Glen Haven Beach

Open Space (Traverse City, MI)

Church of Open Space

Alise's room she built at Have Company

Madcap

Oval Beach (Saugatuck, MI)

Wealthy Theatre

Delaware

Buffalo, NY

A Starbucks somewhere in Delaware

My bedroom on the
other side of the hall

Have Company Kitchen

Fountain Street Church Choir Room

On a walk with John, Siedman Park

Alameda, CA

Oakland, CA

The Oracle, a god damn
Justin Bieber Concert

Sara's Living Room

Sara's Kitchen

Point Reyes & The Ocean

Rachel's backyard (Santa Rosa, CA)

Amongst Redwood trees

Rachel's dining room (Santa Rosa, CA)

Beach (Alameda, CA)

Next to a cactus (Santa Rosa, CA)

Old military yard (Alameda, CA)

Antique store (Alameda, CA)

Spoon Lickers

The Greenhouse, Luxury Commune

The DAAC in an old church

Eliza's Living Room

Toronto

Likely General

Stranger's apartment in Toronto

A Justin Bieber concert in Detroit, MI

Eliza's deck in the rain

The pink kitchen at Pam's

Sunrise, Andrew's spot on the Bay
in Traverse City

Lake Ann, MI Post Office

Beach with Christine

Bedroom, Luxury Commune

In front of Luxury Commune

The aisle at Target

Pool at Luxury Commune

The middle of Have Company
for a performance with Molly

Side of barn in Northern Michigan,
Art by Erin Guido

An abandoned Arby's

Andrew's bay house living room

On a bed in Luxury Commune

Fireplace Luxury Commune

Side of a building in Grand Rapids

Pam's house on Plymouth

David & Sarah's house on Benjamin

Hampton House

Sara's Apartment

Tallulah Fontaine's house

Frank Lloyd Wright house

My brother's house in Philly

Kitchen with Allison and Katie

Behind the old Wealthy Station

Waiting at the vet with Yoko

Andrew's yard

Grand Traverse bay, from the
other side, the sunset side

Living room of Lux Commune

Side porch Lux Commune

Basement of the DAAC

Lake Michigan dip

The entry way of Andrew's
yard and new house

Andrew's new living room

Bombadil Books

Andrew's front yard

My parent's basement

Kendall College of Art & Design

The upstairs bedroom,
a decision for the dog

Dennos Museum

On the rock in Douglas,
in Lake Michigan

Katie Crutchfield's kitchen, Philly

The Jersey shore

Matt's House

Abandoned House on 1-96
between Lansing & Detroit

Hyacinth House

Megabus stop, downtown Grand Rapids

Dee's house, Chicago

Beat Kitchen, Chicago

Yuba River, Grass Valley California

A Third Eye Blind Concert
in Golden Gate Park

The basement of Have Company

Nadia's bedroom, Brooklyn, NY

Christian's parents place in Connecticut

Port Fiber, Portland, Maine

Some water in Maine

Nadia & Christian's living room

Dusty Rose Vintage

A park with Molly,
can't remember the name

Church steps, a man walks out

Ariel's bathtub

Ariel's guest bedroom with
her pregnancy pillow

Ally Jester's basement in Portland

Solabee, Portland, Lana lightly
playing in the background

Lara Jean Gallagher's driveway, Portland

The woods at Megan & Will's wedding

The dance floor at Megan
and Will's wedding

Sidewalk, Ann Arbor

Megan's living room, Ann Arbor

Heritage Hill sidewalk
on my way to Have Company

Maru, Grand Rapids

Lakeside Motel

Motel 6, Omaha, NE

Buford One

Sunrise, Wyoming

Hills, Boise, Idaho

Rome, Oregon

Oakland, CA

SF Moma

Downstairs room in Trinity's room

Trinity's back deck

Homestead Apothecary

The Ocean in Santa Cruz

Carly & Rob's Basement

The most sacred bathtub, Willow Street

Prism House, in my new room

Foggy Notion, Oakland

Abandoned Flower Farm, San Francisco

Prism House Kitchen

Finnish Hall, Berkeley

Pieter Space, LA

EPILOGUE:
IN GRATITUDE

For Katherine, Pam, Lisa, & Jen : for showing up over and over and over again. Even when it is messy, especially when it is messy. Your friendships with each other and professional work & research in this world guided me into this project

For Pam, there are no words for the advice, love, and patience you have taught me

For Tori, Emily, & Marie, for continuing the legacy & being in even when we are out

For George, I miss you all the time. Thank you for inventing the Ann Arbor Film Festival, thank you for being my collaborator, I love you and you are with me every day & you pushed me deeper into my work & I am forever grateful for that

For Megan, for being born 2 weeks before me so that when I got into this world I wasn't the only gemini freak

For Ariel, for actually scooping me off floors, hardly a day gone by without an I love you

For Sara, few friends call me on my bullshit like you do in an attempt to love me deeper, thank you for loving this project before you even loved me

For Sarah, for reading this before anyone else did and elevating it to it's greatest potential

For Dori, wildness alivesness god & the reminder that the homework of my life is self forgiveness

For Figgy, Alyssa, Heather, Jacki, Joanna, Eliza, Nickey, Rachel - Michigan is my home and you all are so deeply a part of my life & time there and you are magic friends

For Kacey, for being generous with your home where I finished this book

For Mary, thank you for supporting my work
& facilitating it's growth. Both my podcast
& this project would not have been born
without your encouragement.

For John, for loving me and letting it go

For Brian, for showing me what being so
completely seen feels like

For Andrew D, for so many swims and forever
reminders that I can do anything

For my Mom, for laughing and always
listening and never judging

For my Dad, for every song suggestion, back
rubs while I cry, the only Scorpio I'll ever trust

For Sam CP, how lucky to have one of my best
friends be my only sibling

For Andrew M, endless inspiration &
admiration & air sign magic

For every resident artist that has ever been
to Have Company, you have no idea how
deeply you changed me

For every person who backed this project

For Richard, being a true true friend on this
journey, and for laying out this book

For you & you & you & you

Marlee Grace is an improviser & a
writer living in rural California

She works with improvisation as a
method for navigating being alive
& making work through movement,
quilting, writing, & podcasting

Marlee has a BFA in Dance from the
University of Michigan

She facilitates classes & events for her
own work & for others in the mediums
of dance, blanket making, & work/life
balance conversations

She used to run a space in Grand Rapids, MI called Have Company & there is a podcast that chronicles that project

Visit have-company.com/podcast to listen

Marlee loves to help other artists/ humans unlock what is blocking them creatively through one on one creative mapping sessions - email her about it

She is also working on a book called *How to not Always be Working* which is a spiritual & practical toolkit for taking breaks and loving your work and your life. That book comes out Fall of 2018

you can email her at softsoftprocess@gmail.com

and send mail to
po box 123
point reyes station, ca
94956

Made in the USA
San Bernardino, CA
04 August 2017